MU00483624

THIS NOTEBOOK BELONGS TO

CONTACT